THIS
Lazy Greyhounds
Coloring
Book

BELONGS TO:

...

DATE:

...

©IslandSmiles Press

All rights reserved. No part of this publication may be reproduced, distributed or transmitted in any form or by any means including photocopying, recording or other electronic methods without the prior written permission of the publisher.

Lazy Greyhounds Coloring Book

©IslandSmiles Press. All rights reserved.

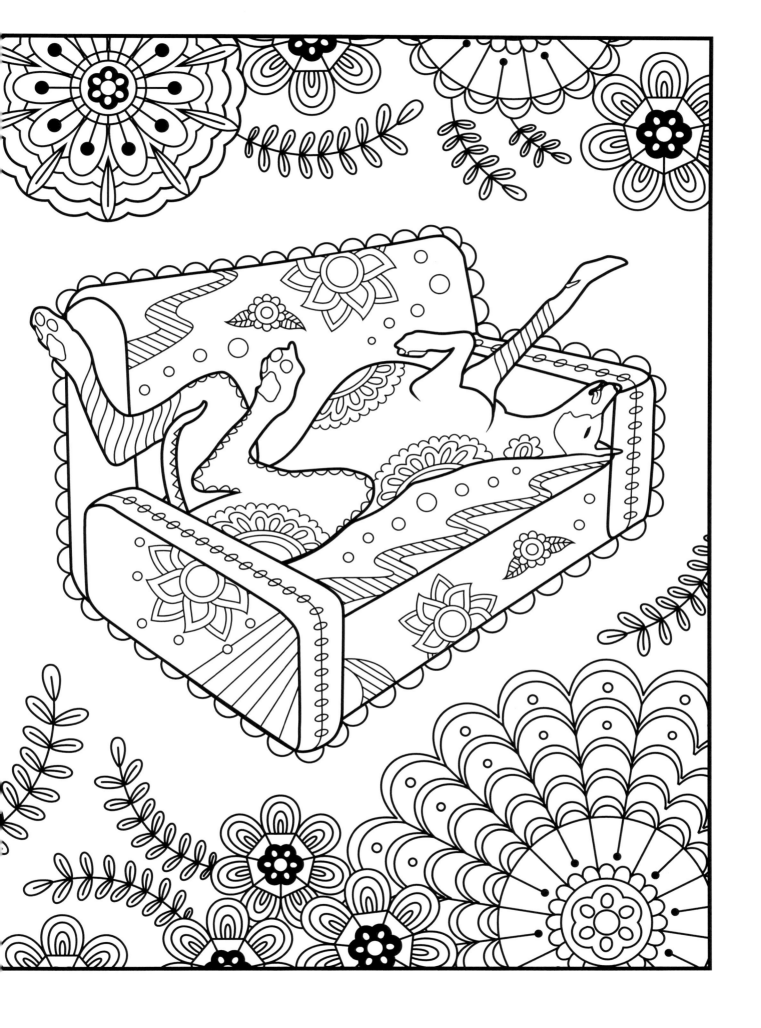

Lazy Greyhounds Coloring Book

©IslandSmiles Press. All rights reserved.

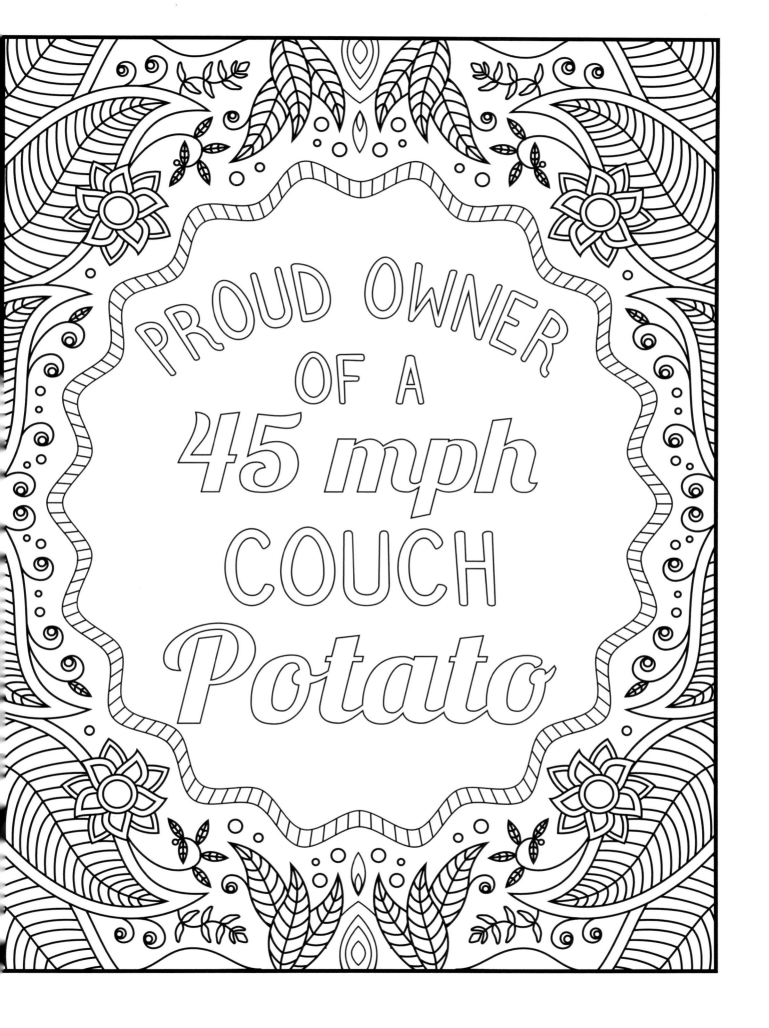

Lazy Greyhounds Coloring Book

©IslandSmiles Press. All rights reserved.

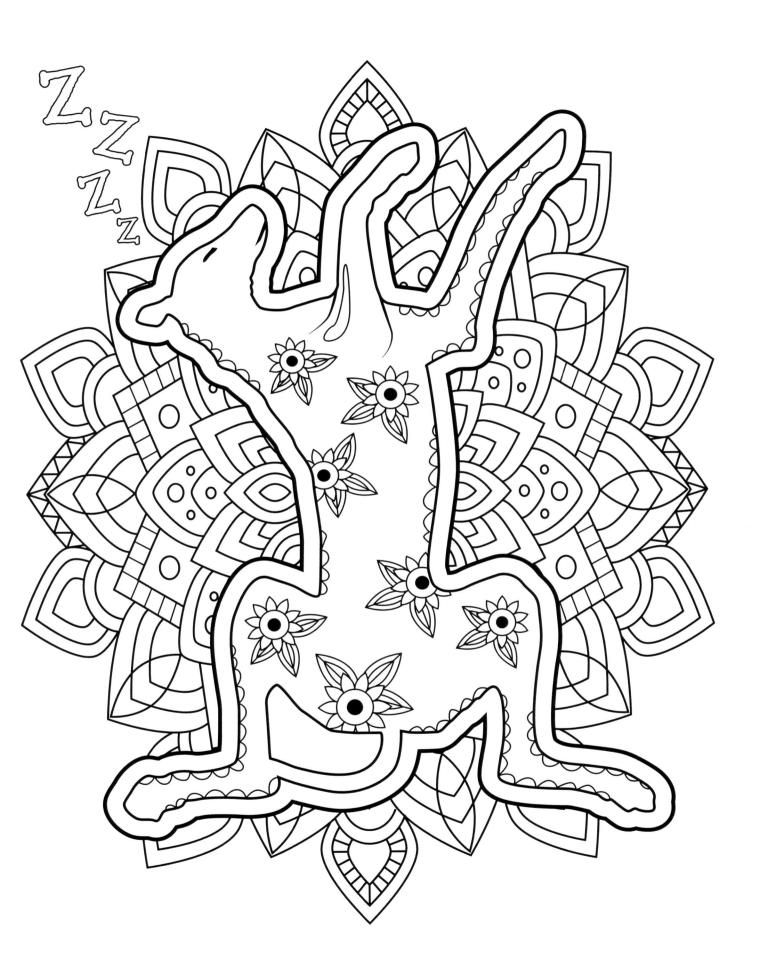

Lazy Greyhounds Coloring Book

©IslandSmiles Press. All rights reserved.

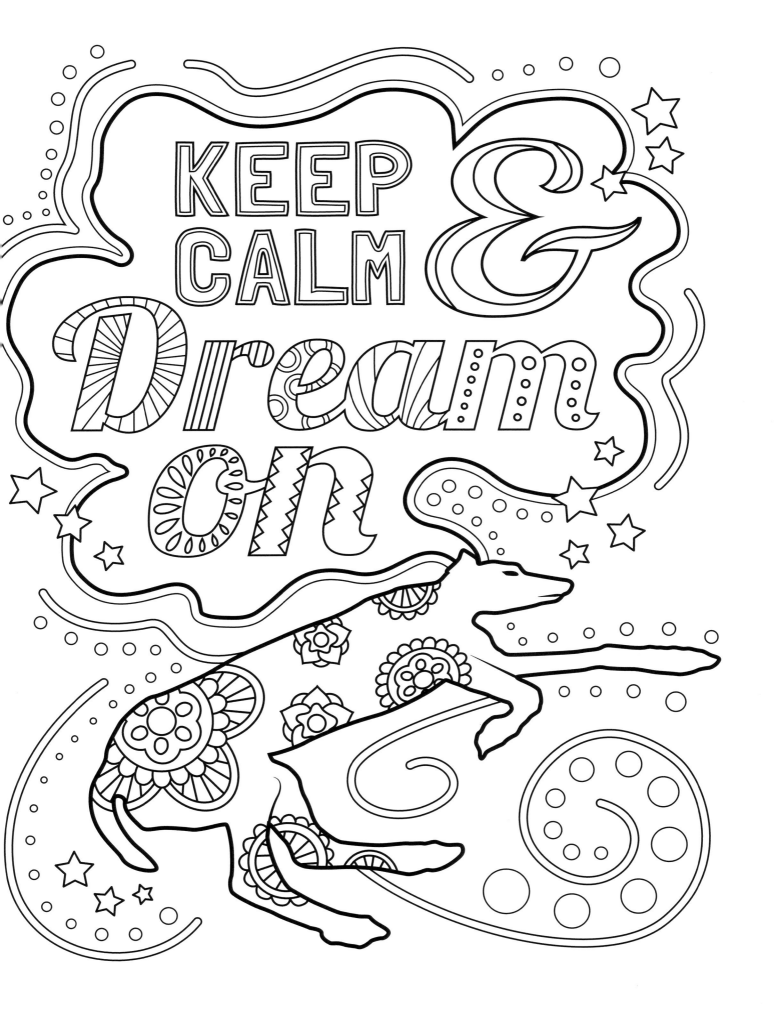

Lazy Greyhounds Coloring Book

©IslandSmiles Press. All rights reserved.

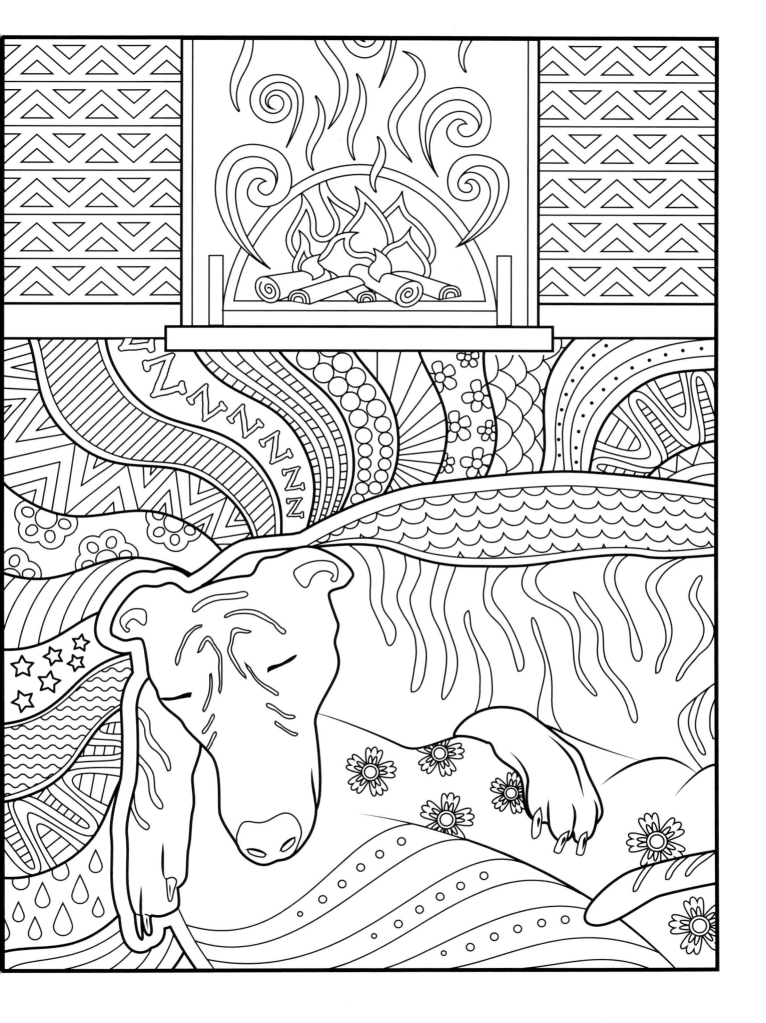

Lazy Greyhounds Coloring Book

©IslandSmiles Press. All rights reserved.

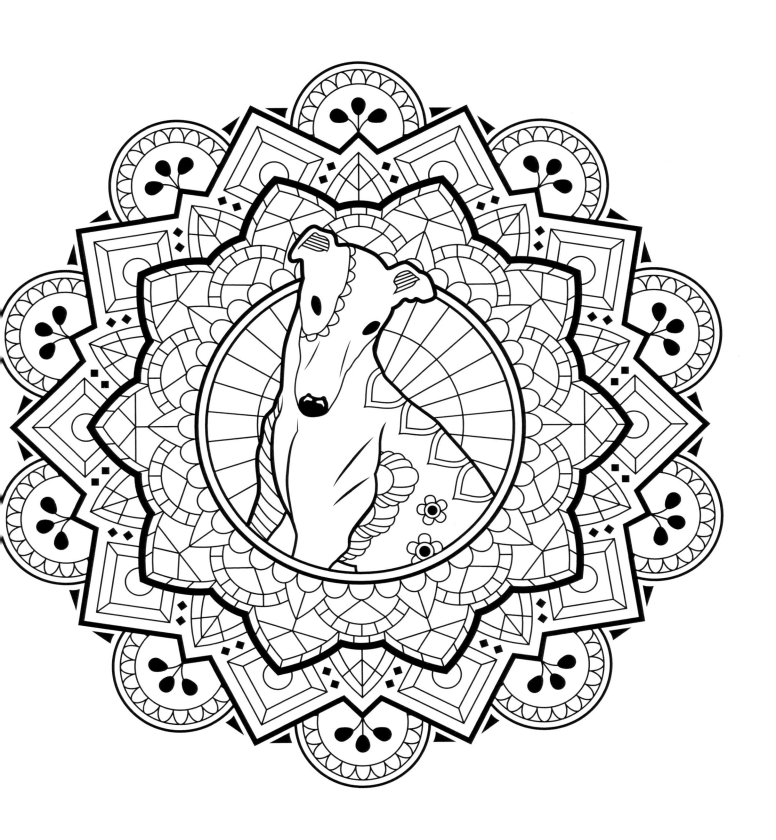

Lazy Greyhounds Coloring Book

©IslandSmiles Press. All rights reserved.

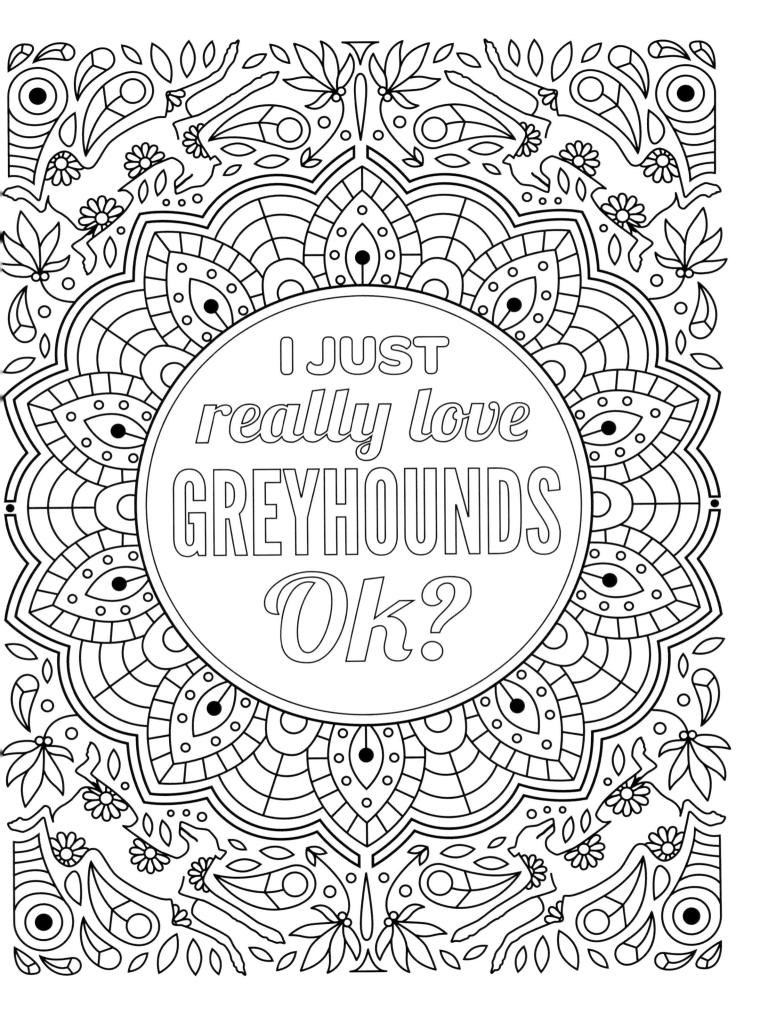

Lazy Greyhounds Coloring Book

©IslandSmiles Press. All rights reserved.

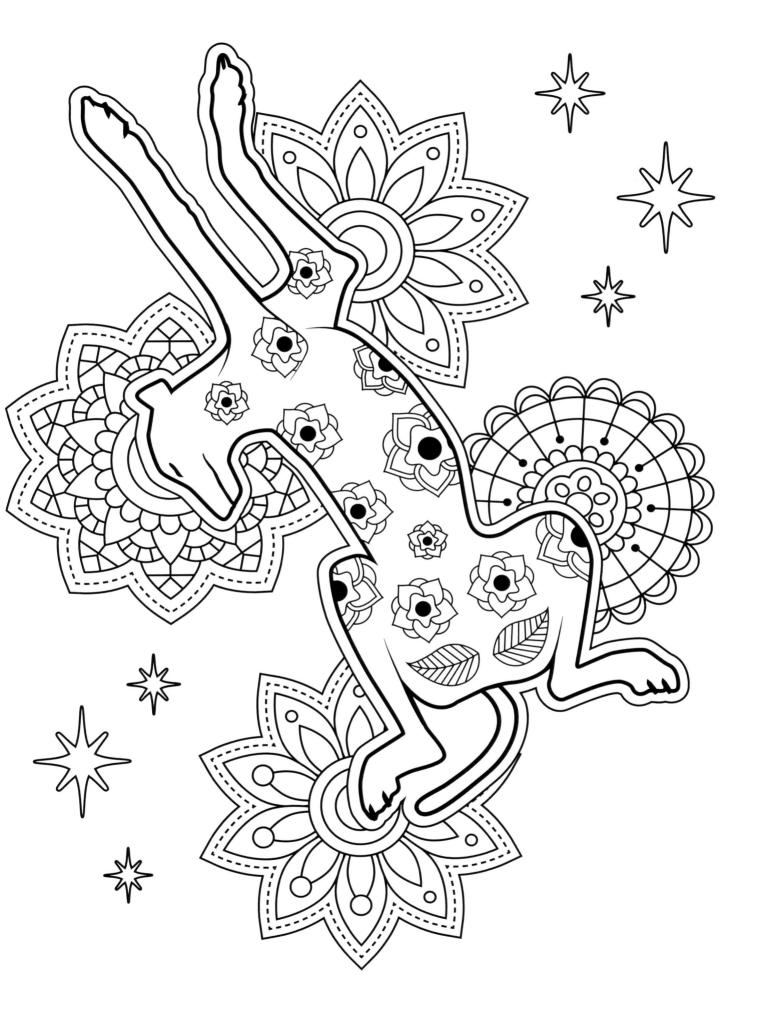

Lazy Greyhounds Coloring Book

©IslandSmiles Press. All rights reserved.

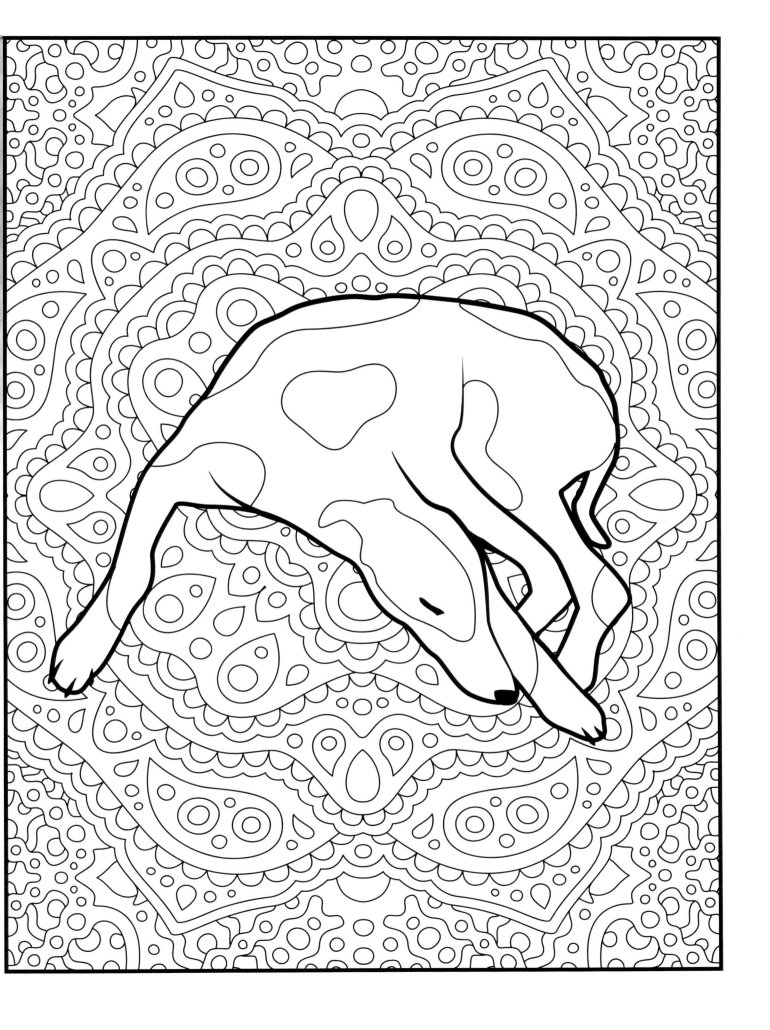

Lazy Greyhounds Coloring Book

©IslandSmiles Press. All rights reserved.

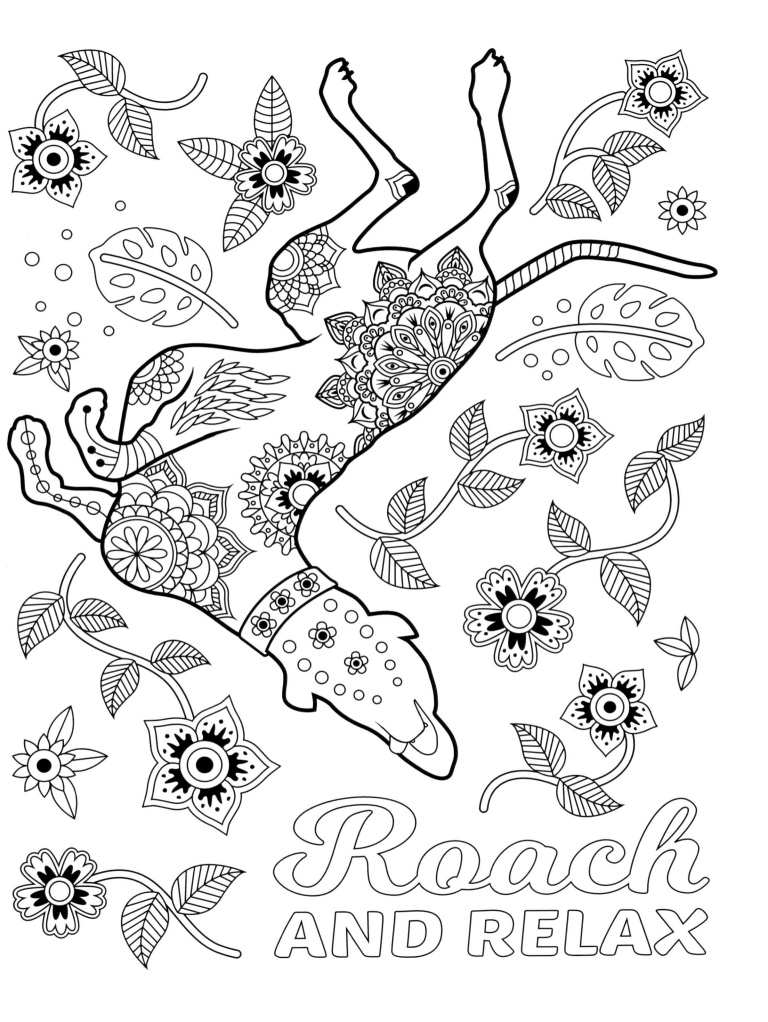

Lazy Greyhounds Coloring Book

©IslandSmiles Press. All rights reserved.

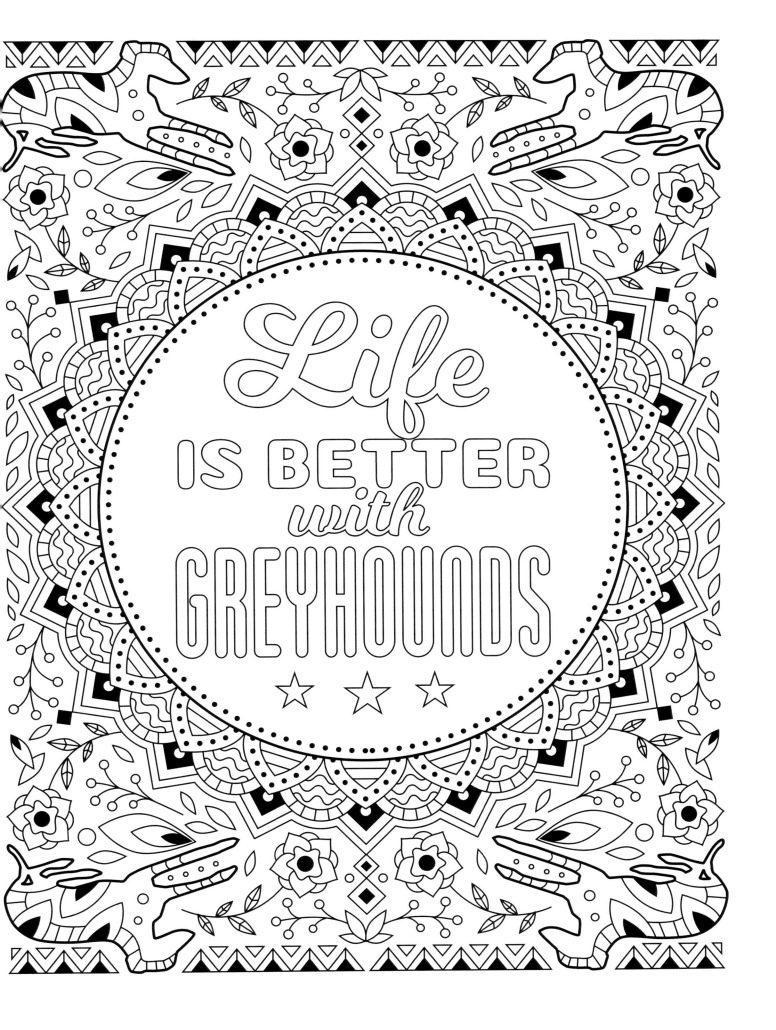

Lazy Greyhounds Coloring Book

©IslandSmiles Press. All rights reserved.

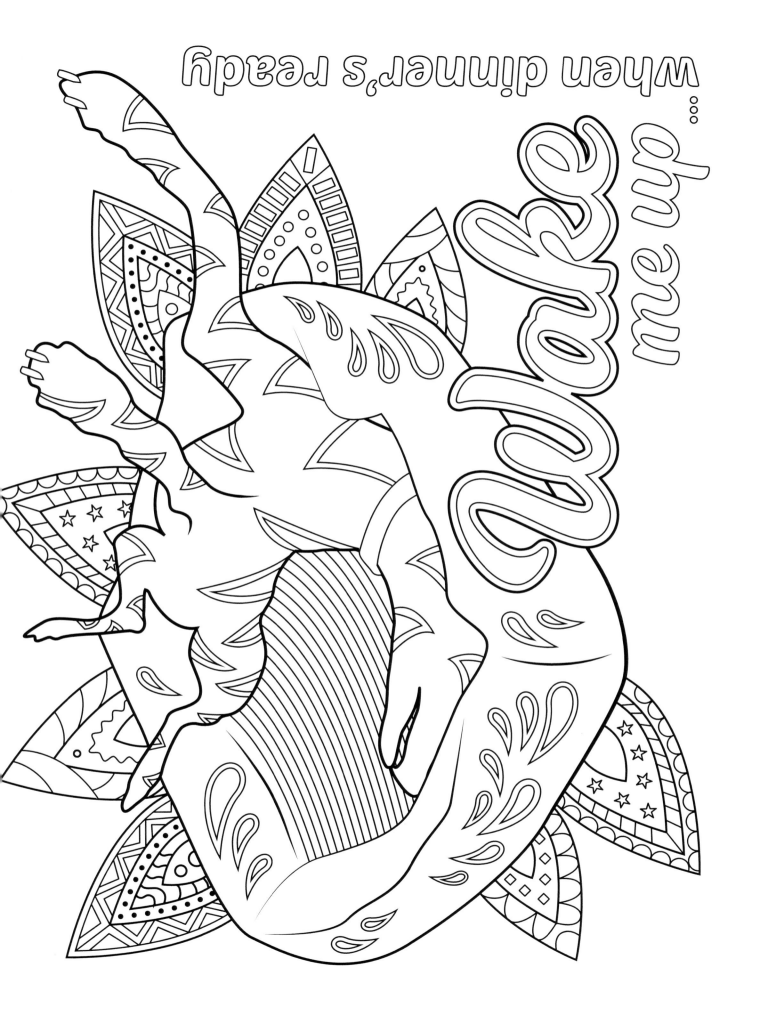

Lazy Greyhounds Coloring Book

©IslandSmiles Press. All rights reserved.

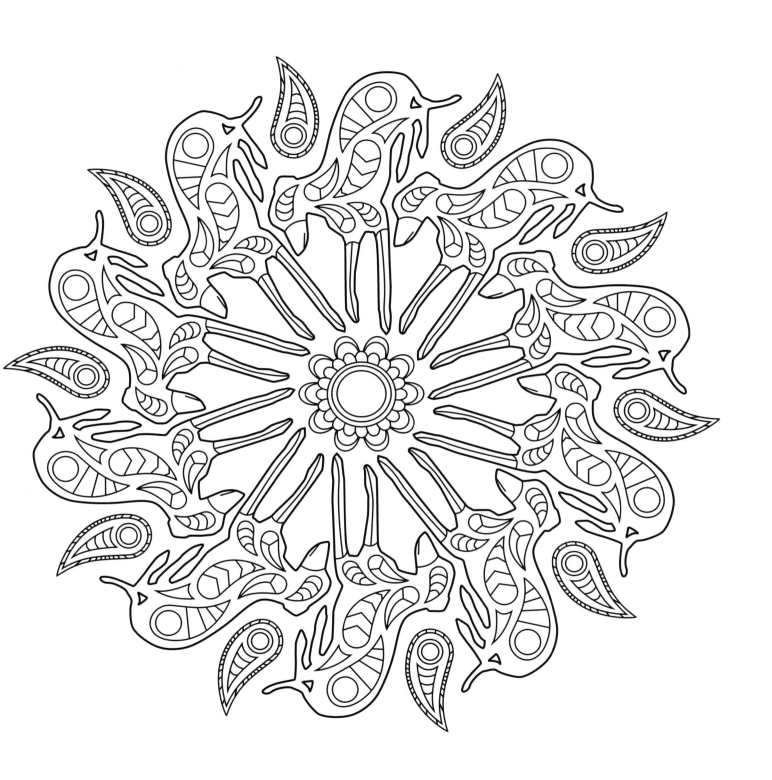

Lazy Greyhounds Coloring Book

©IslandSmiles Press. All rights reserved.

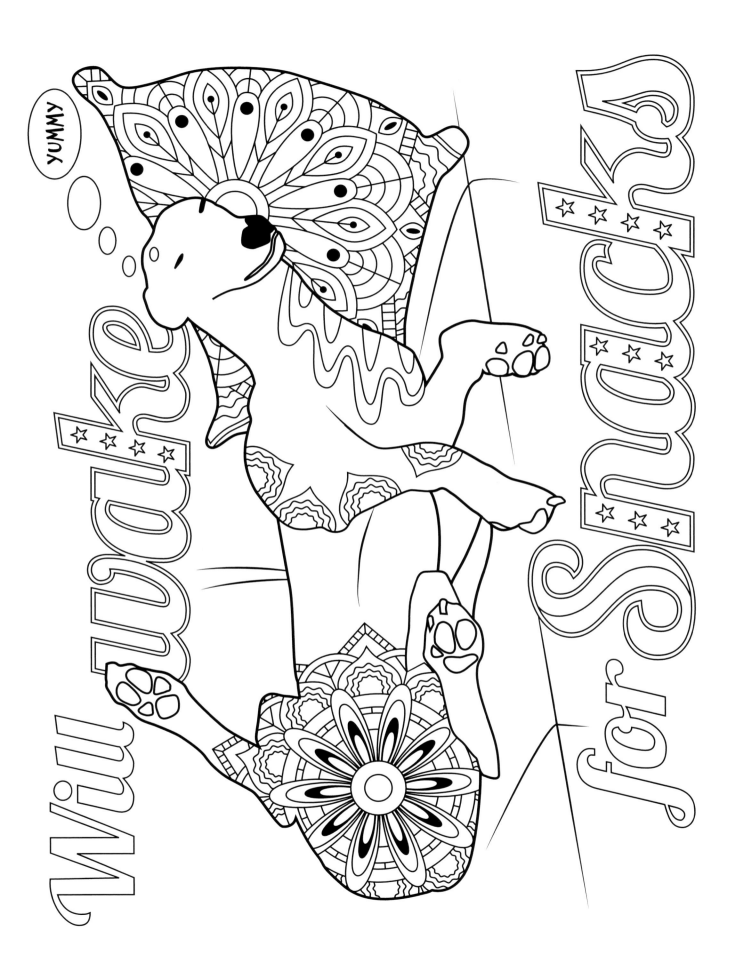

Lazy Greyhounds Coloring Book

©IslandSmiles Press. All rights reserved.

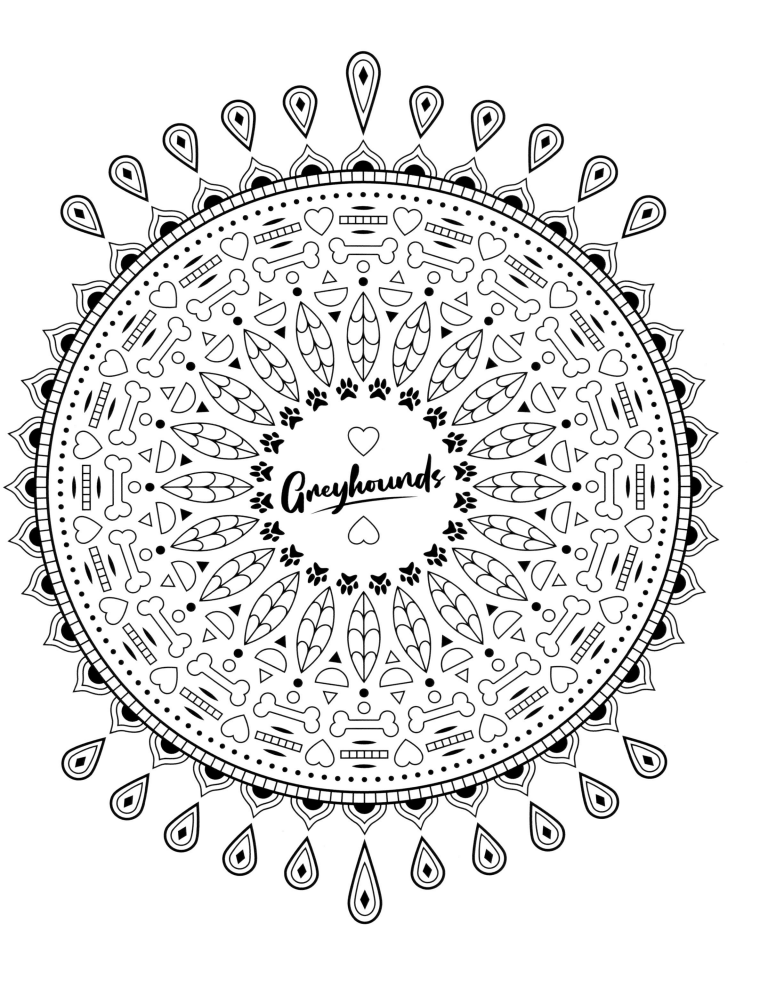

Lazy Greyhounds Coloring Book

©IslandSmiles Press. All rights reserved.

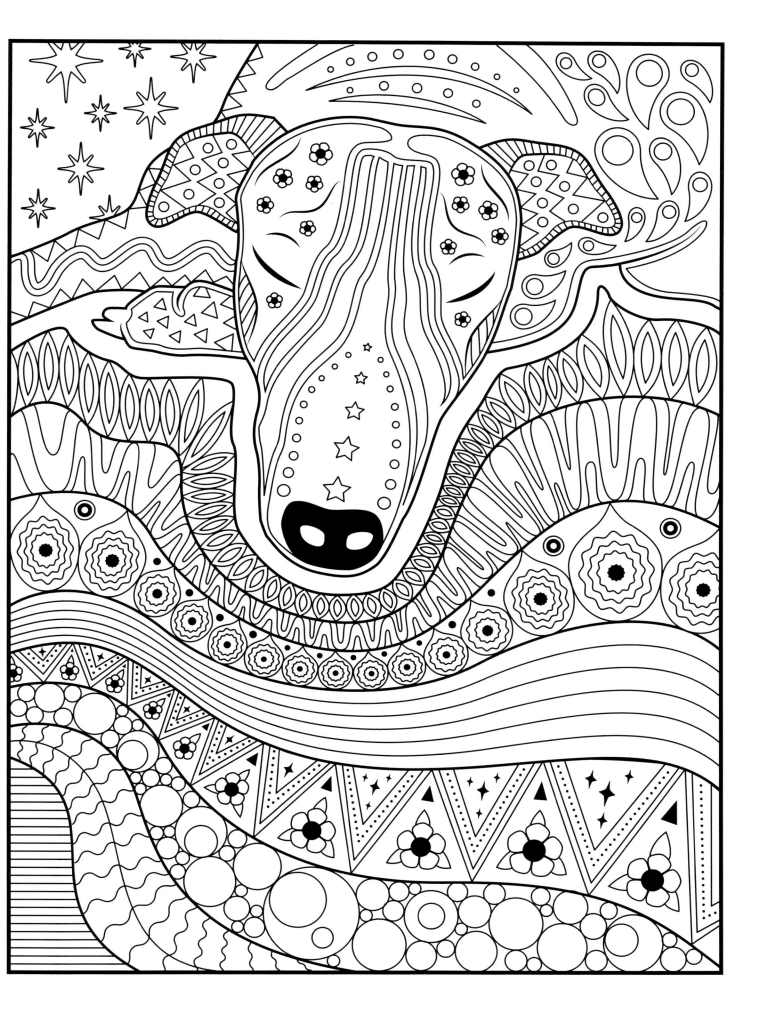

Lazy Greyhounds Coloring Book

©IslandSmiles Press. All rights reserved.

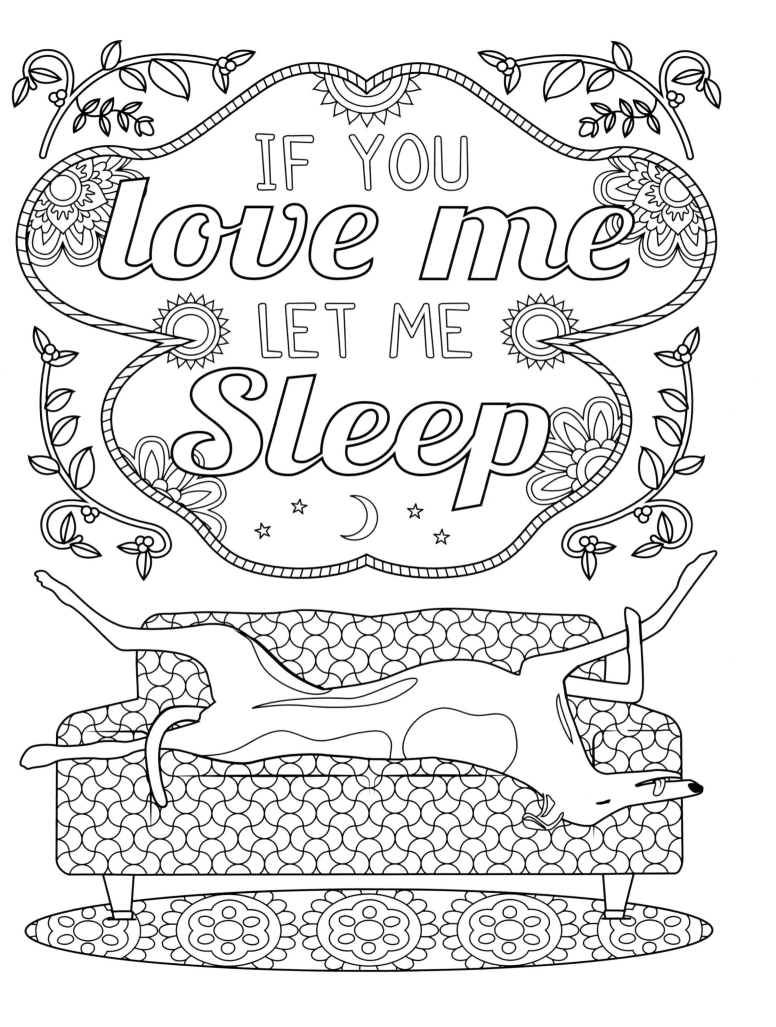

Lazy Greyhounds Coloring Book

©IslandSmiles Press. All rights reserved.

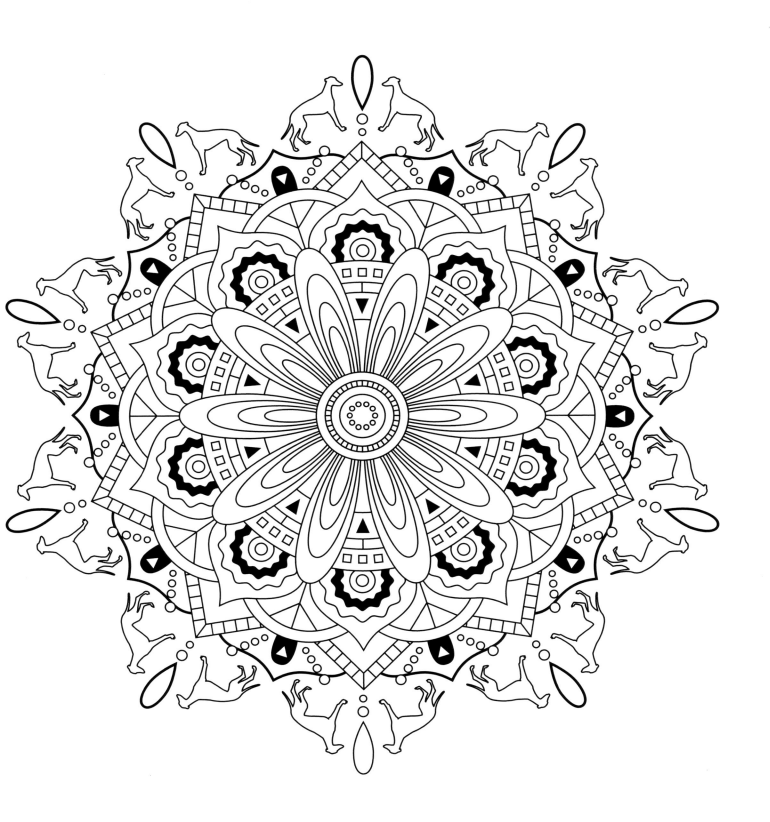

Lazy Greyhounds Coloring Book

©IslandSmiles Press. All rights reserved.

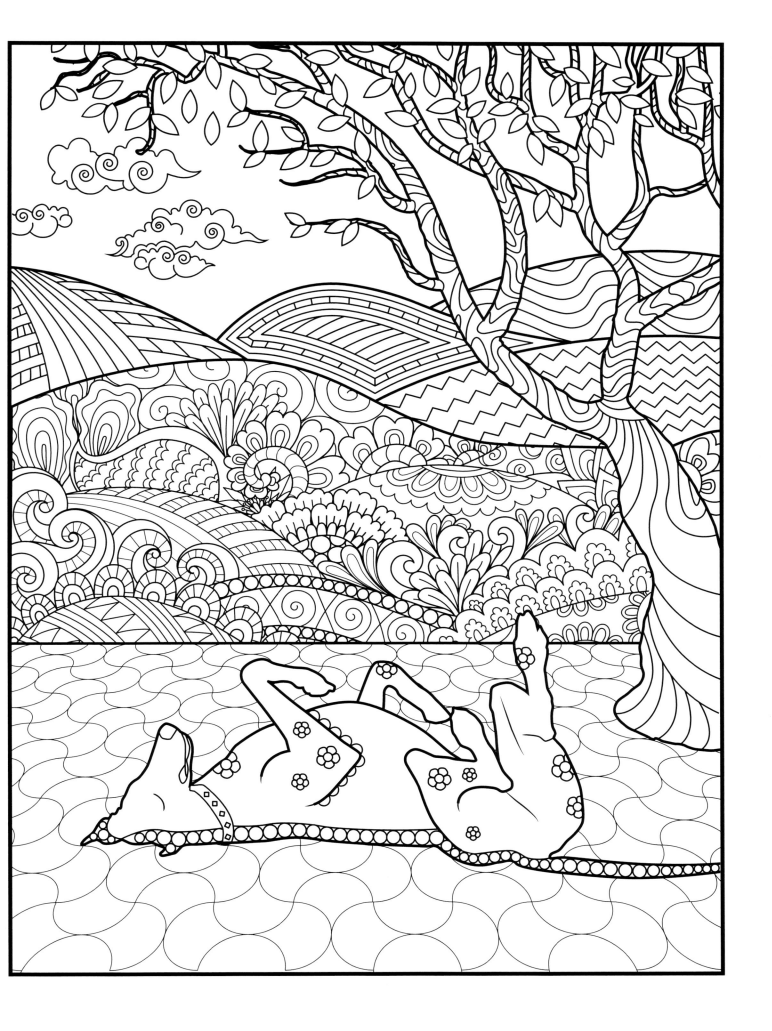

Lazy Greyhounds Coloring Book

©IslandSmiles Press. All rights reserved.

Just Resting

with my eyes closed

Lazy Greyhounds Coloring Book

©IslandSmiles Press. All rights reserved.

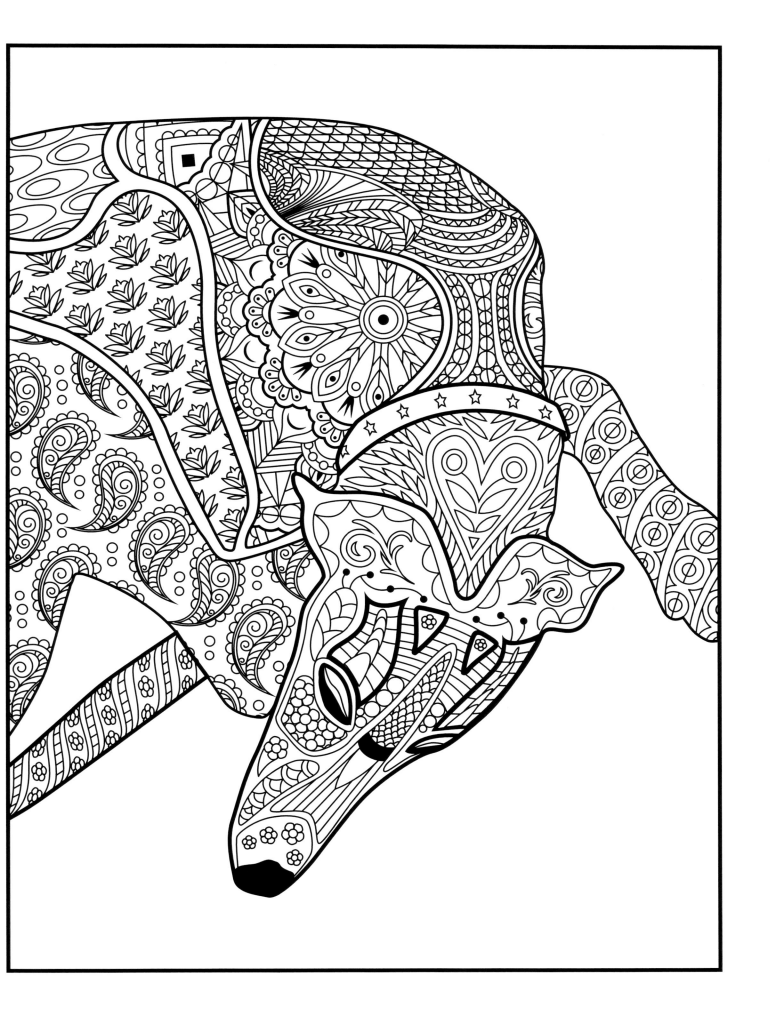

Lazy Greyhounds Coloring Book

©IslandSmiles Press. All rights reserved.

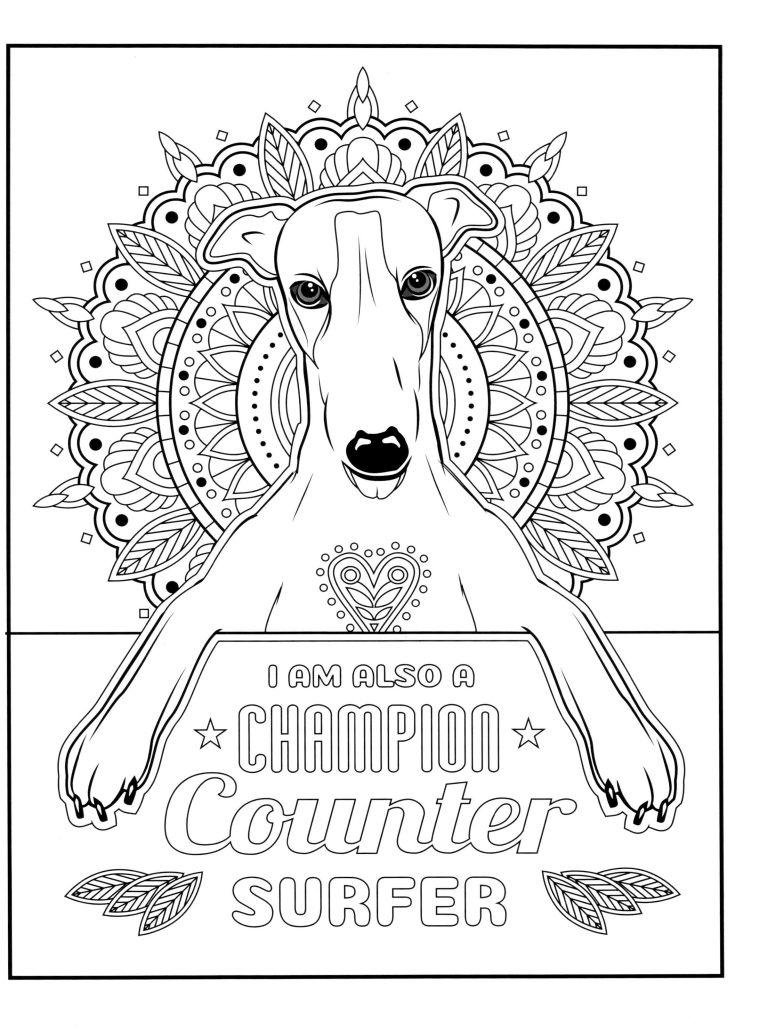

Lazy Greyhounds Coloring Book

©IslandSmiles Press. All rights reserved.

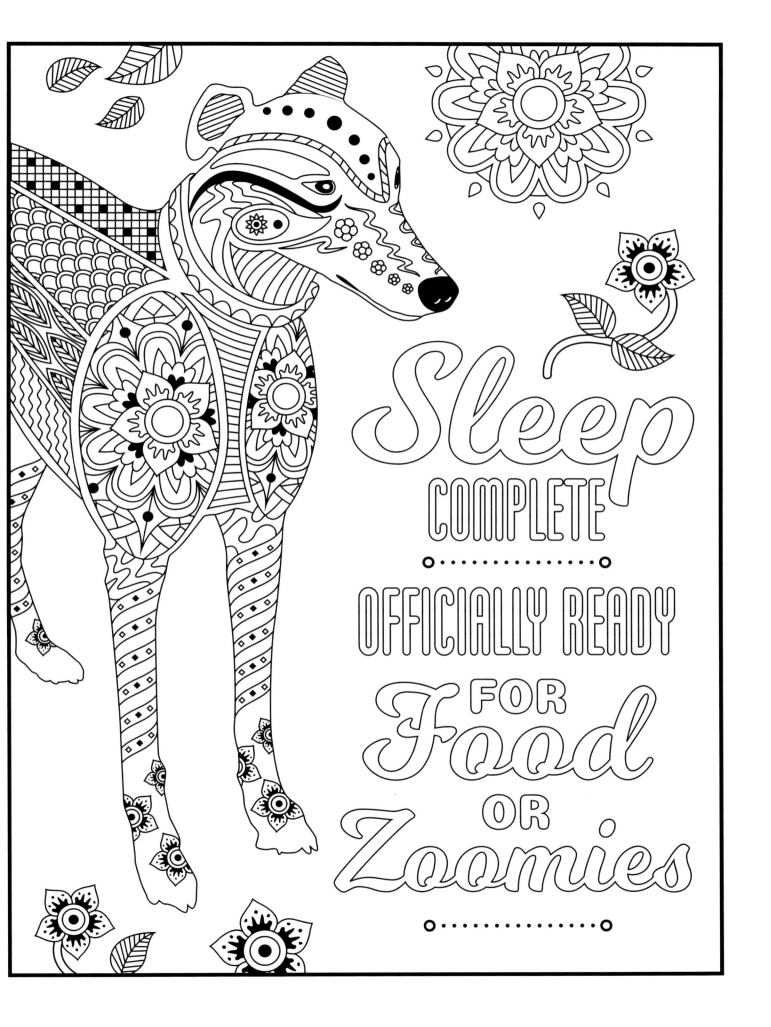

Lazy Greyhounds Coloring Book

©IslandSmiles Press. All rights reserved.

Made in United States
North Haven, CT
23 July 2025

70957260R00028